7/20/05

Janice

my friend:

Get well fast from
Hungary, there's
too much to do —
your friend much

God Bless — Love

Roxy

What Animals Teach Us...

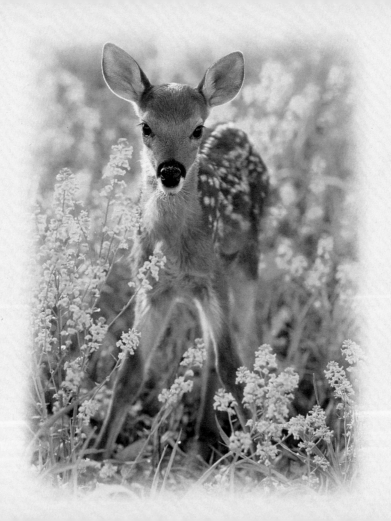

What Animals Teach Us...

LIFE'S LESSONS LEARNED FROM THE ANIMALS AROUND US

Willow Creek Press

Published by Willow Creek Press
P.O. Box 147, Minocqua, Wisconsin 54548

Editor/design: Andrea Donner

Library of Congress Cataloging-in-Publication Data
Donner, Andrea K., 1967-
 What animals teach us : life's lessons learned from the animals around us / Andrea K. Donner.
 p. cm.
 ISBN 1-59543-060-1 (hardcover : alk. paper)
 1. Health. 2. Conduct of life. 3. Animals--North America--Pictorial works. I. Title.
 RA776.D673 2004
 613--dc22

2004018011

Printed in Canada

TABLE OF CONTENTS

On
Healthy Living

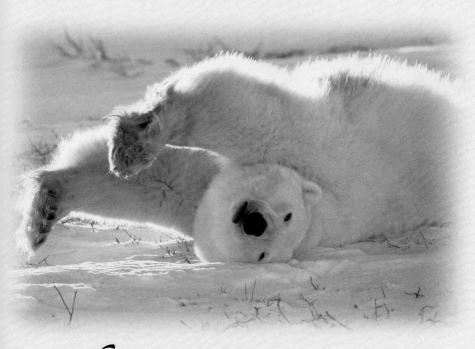

Start each day with a real good stretch.

Yoga ...

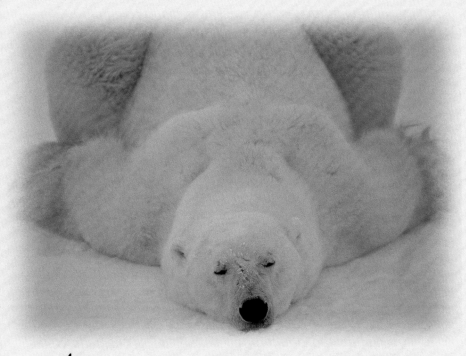

And meditation are also great for relaxation.

Make sure your diet includes plenty of fruit ...

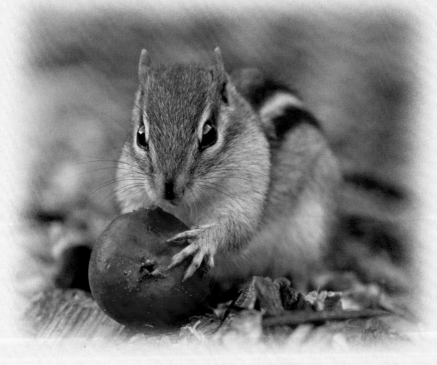

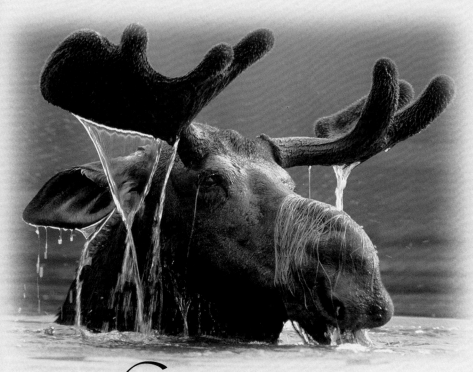

Green vegetables ...

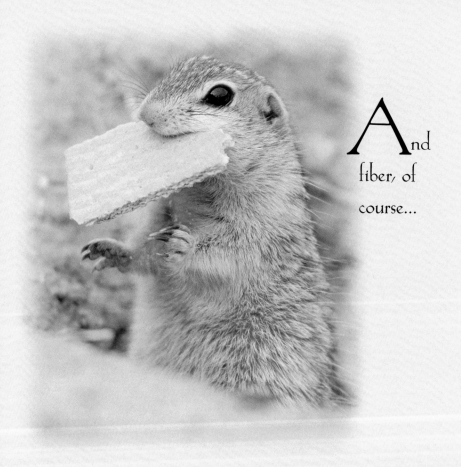

And
fiber, of
course...

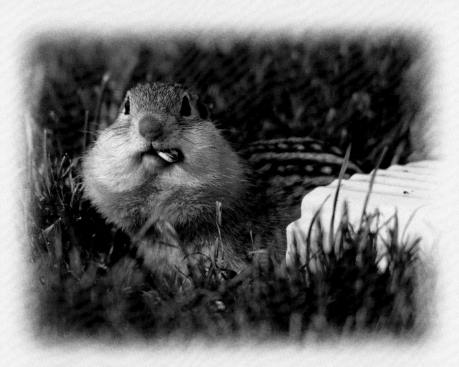

With a few treats every now and then too.

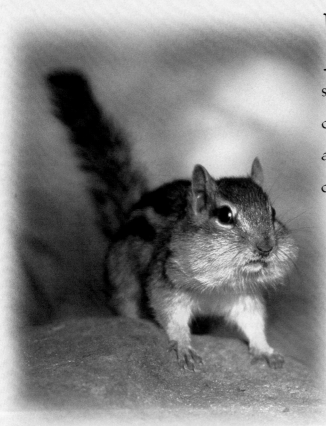

It's even fun to stuff yourself on very rare and special occasions!

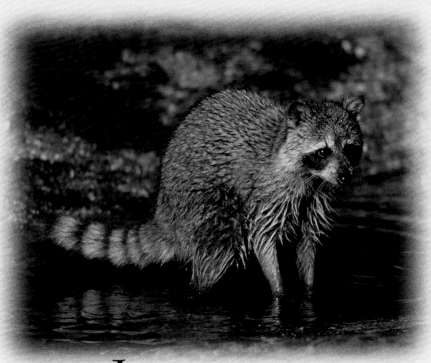

Just make sure to wash your
hands before every meal.

Drink plenty of water.

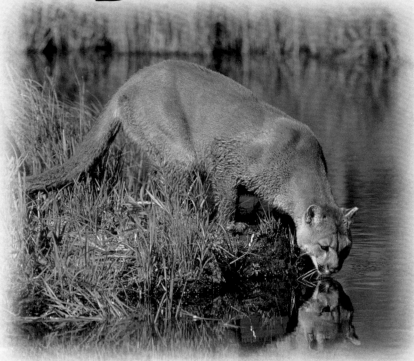

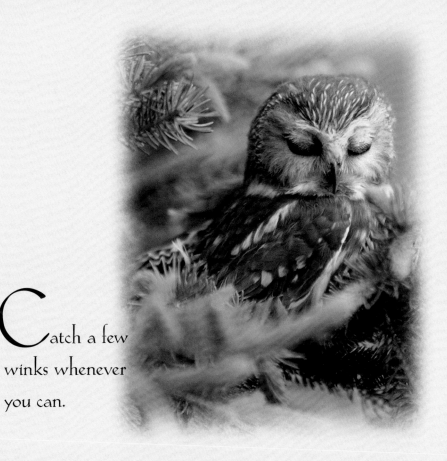

Catch a few
winks whenever
you can.

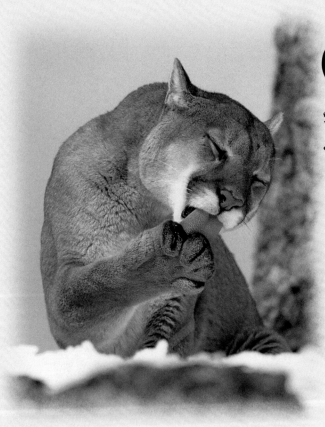

G

ood
grooming is
an asset.

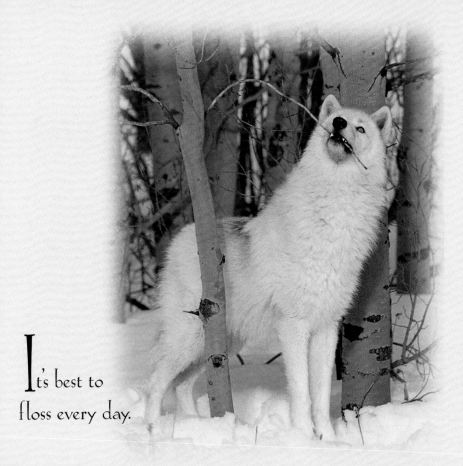

I't's best to floss every day.

Try to get adequate exercise...

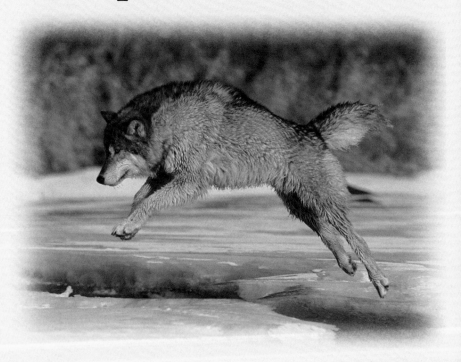

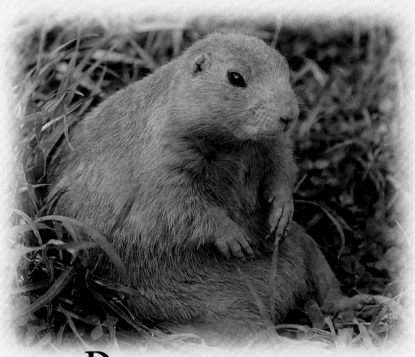

B ut don't get down on yourself
if you put on a few pounds.

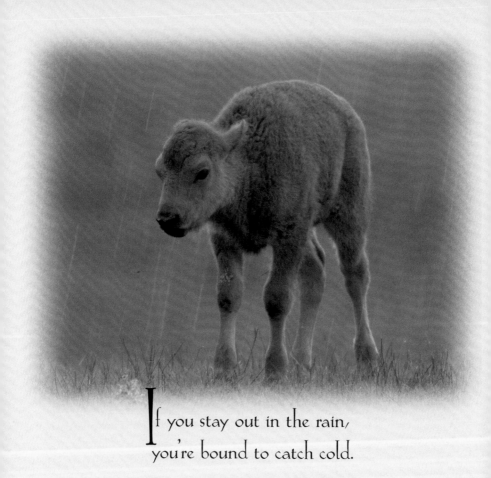

If you stay out in the rain,
you're bound to catch cold.

Scratch what itches.

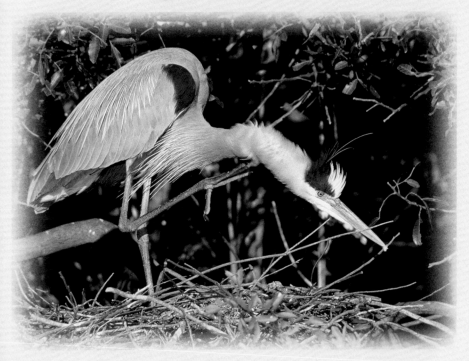

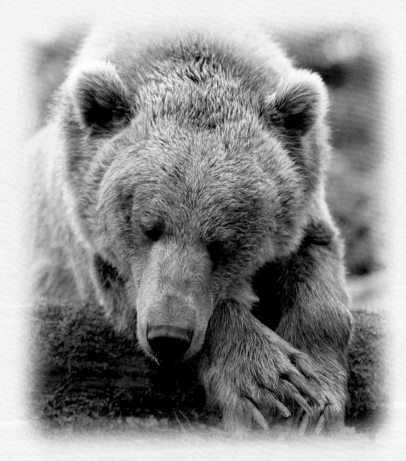

Take time out of your busy day to relax, breathe deeply, and ignore the stress around you.

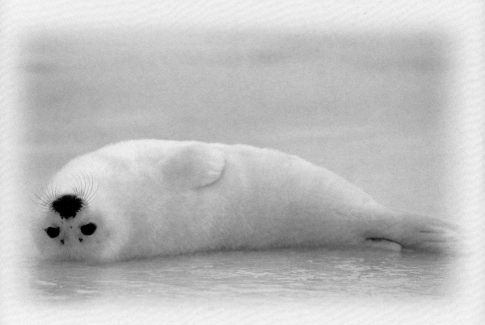

On Love
& Friendship

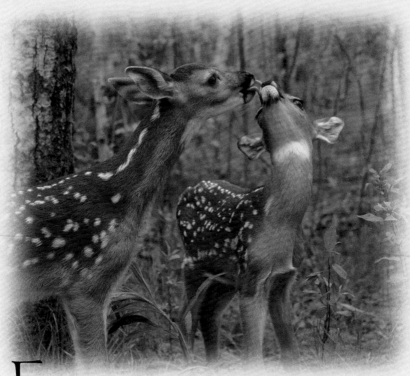

Engage in PDAs (public displays of affection)
with the ones you love.

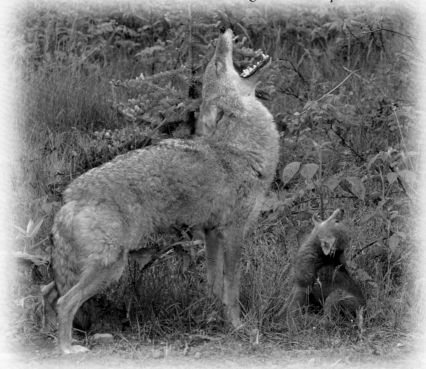

When you know someone you love and respect, strive to imitate their good example.

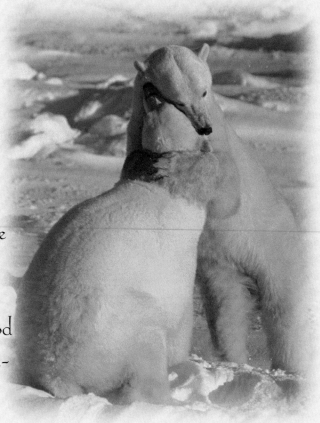

A simple hug can make the difference between a good day and a not-so-good day.

A good friend can help you weather any storm.

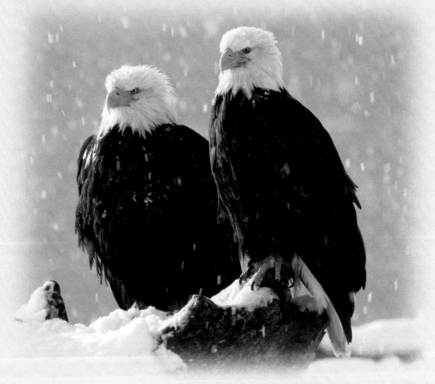

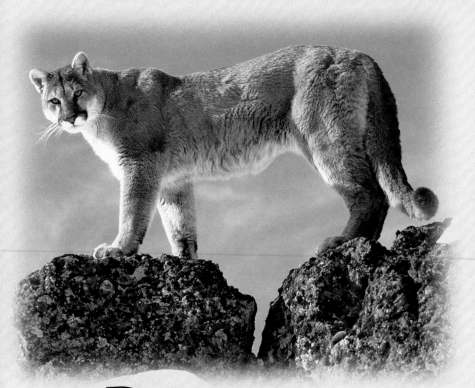

 D on't look down on others.

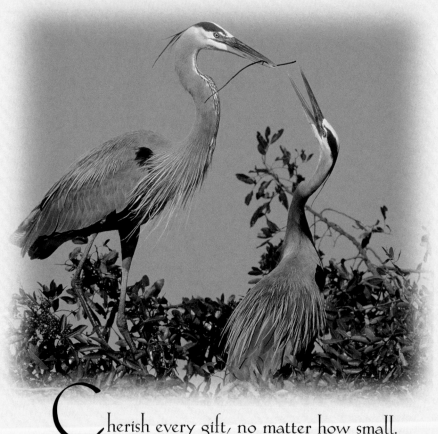

Cherish every gift, no matter how small.

Always support a friend in need.

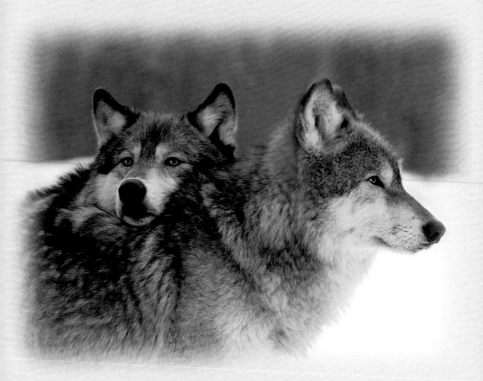

Be interested in others...

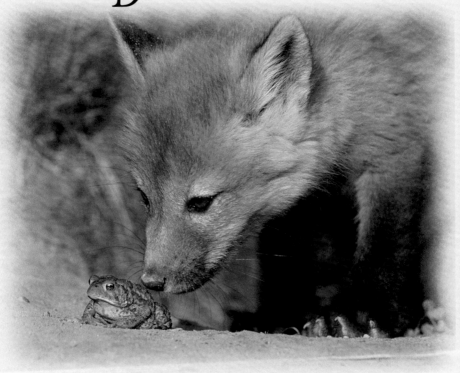

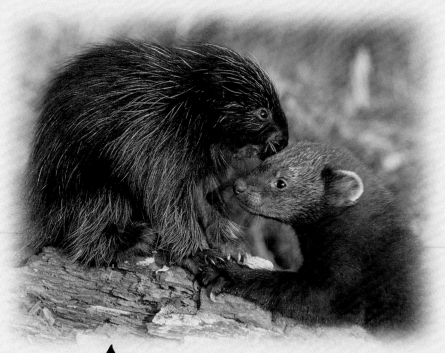

And accepting of those who
look different than you.

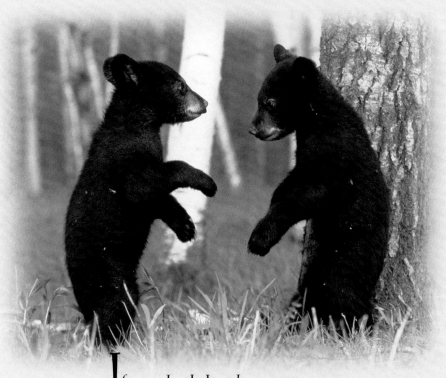

If you look hard, you can see
yourself in your friends.

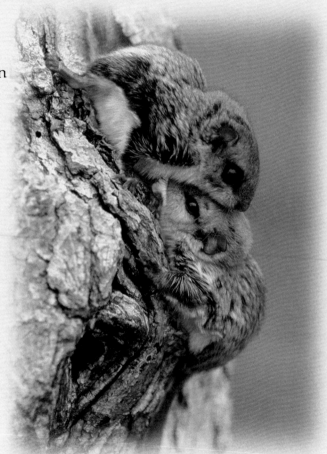

H old on
to the ones
you love.

Be gentle and tolerant around kids.

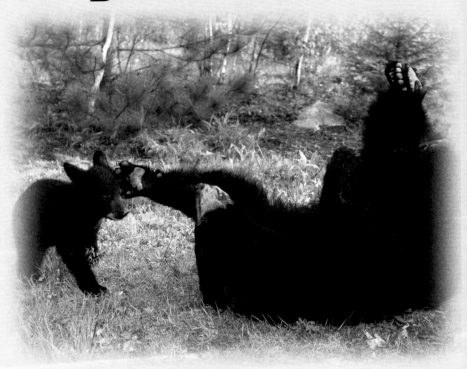

Kindness
is one of the
greatest gifts
you can give
to the young.

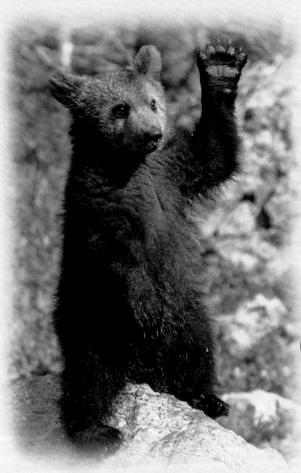

G reet
your friends
with enthusiasm.

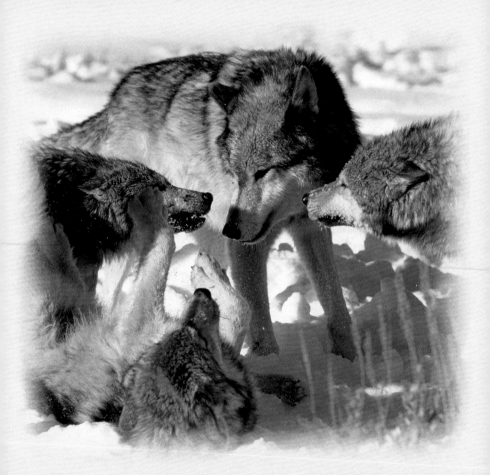

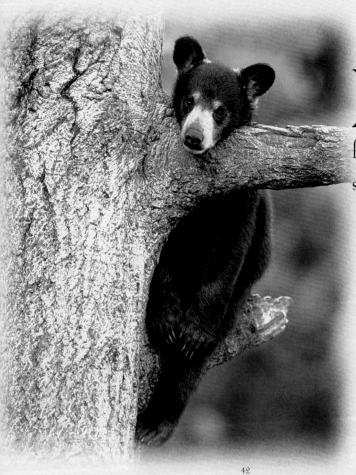

E veryone

feels lonely

sometimes...

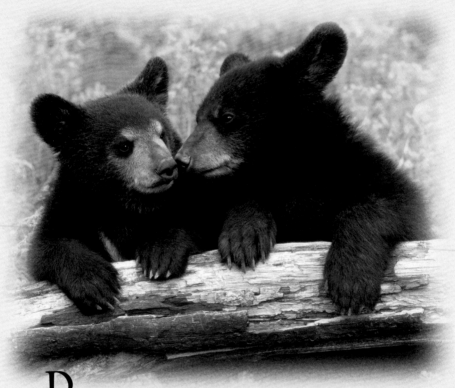

But if you look, a friend can always be found.

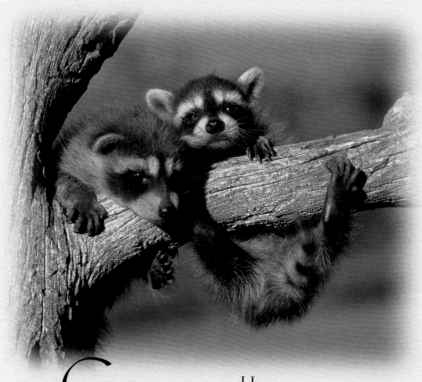

Getting into trouble is more
fun with a good friend.

E specially one who won't be mad
at you if it's your fault.

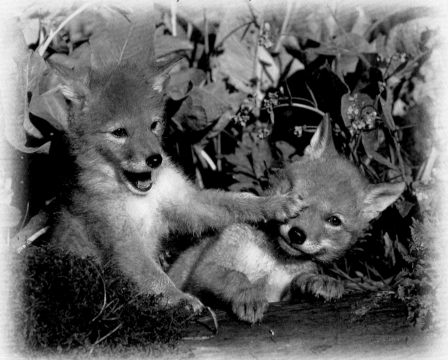

Sassing back only makes things worse.

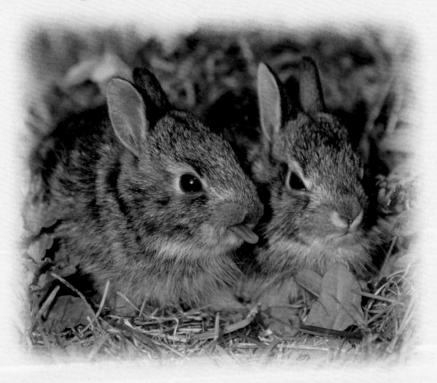

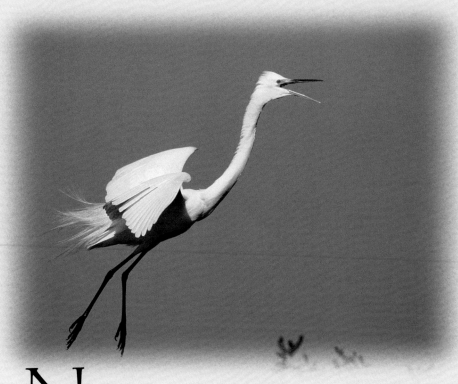

N ever show up at a friend's house unannounced.

The world can always use a little more gentleness.

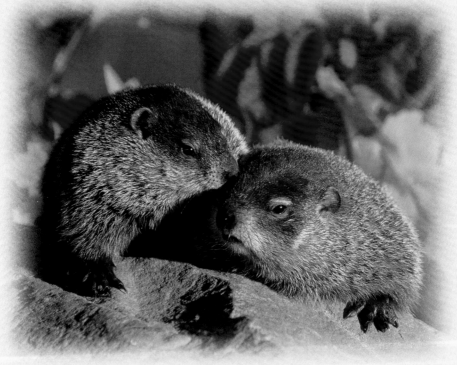

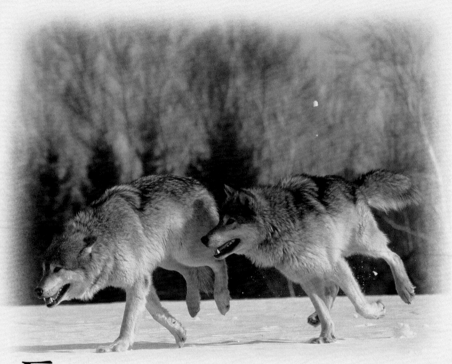

Everything is more fun when shared with a friend.

On
Self-Esteem
&
Self-Improvement

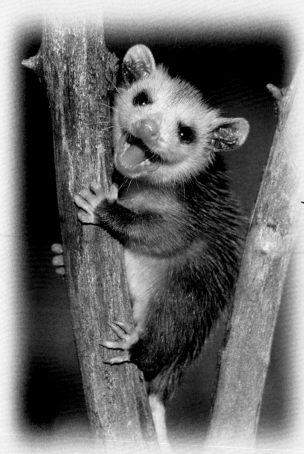

Who
you are is
infinitely more
important
than how
you look.

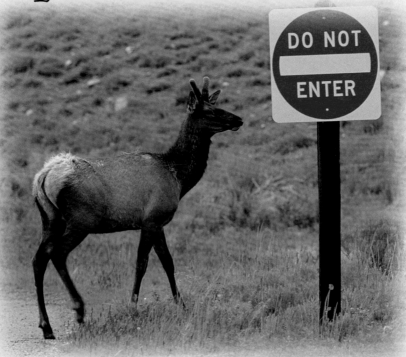

For the most part, try to obey the rules...

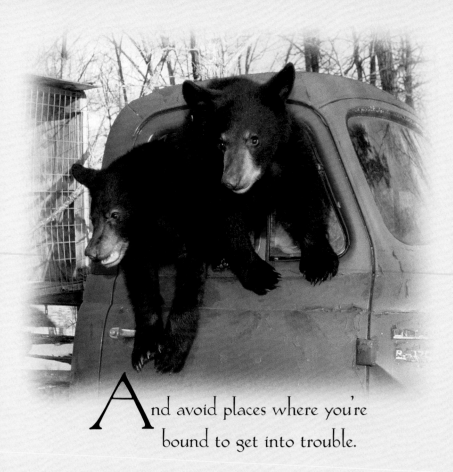

And avoid places where you're
bound to get into trouble.

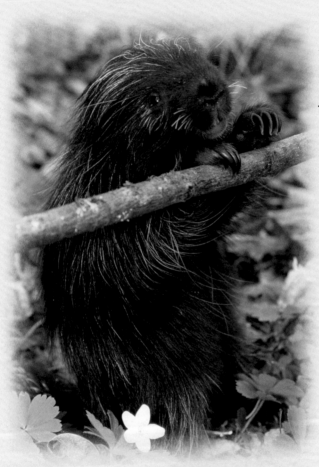

Be happy
with who
you are.

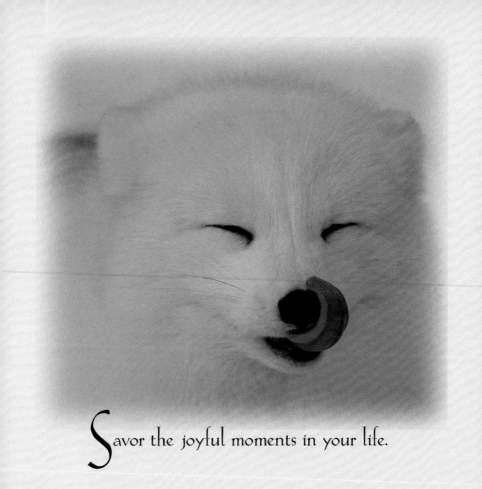

Savor the joyful moments in your life.

Don't be afraid to go out on a limb...

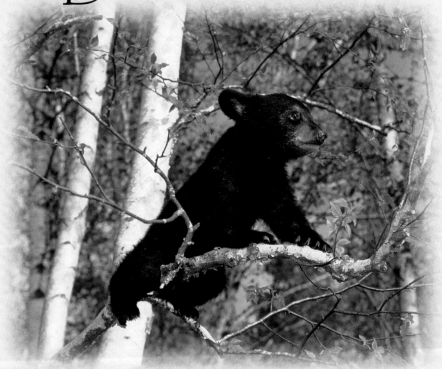

Or stick
your neck
out for the
right cause.

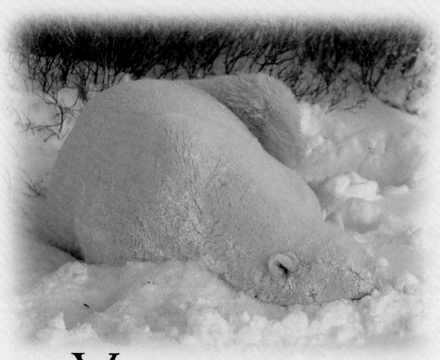

Y ou can't hide from your problems...

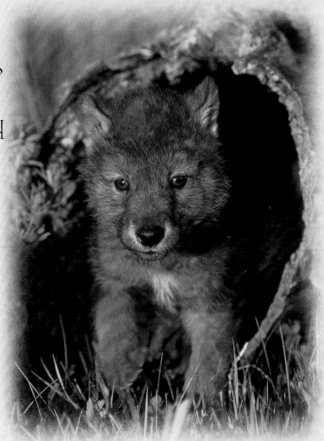

Y ou have to
force yourself
to go out and
face them.

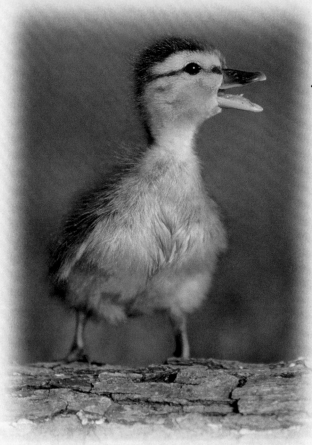

Speak up
if you have
something
to say.

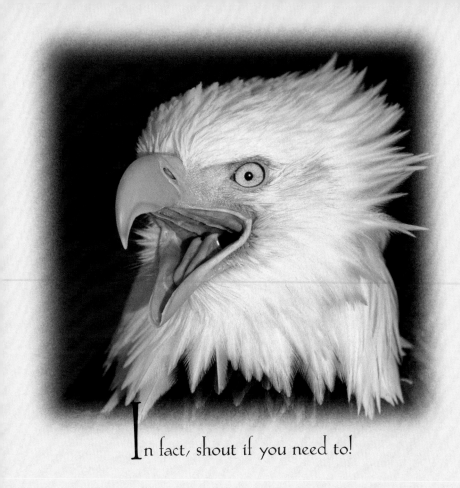

In fact, shout if you need to!

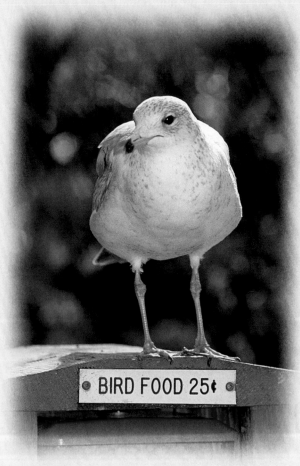

Be prepared for every opportunity.

BIRD FOOD 25¢

Don't let
a bad hair day
get you down.

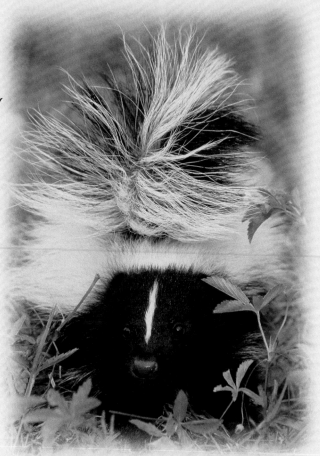

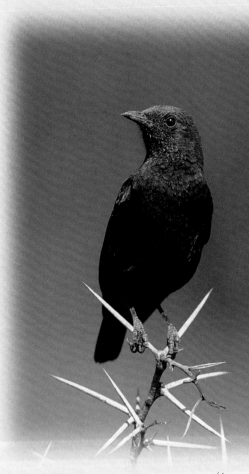

L ife is full
of thorns; the
trick is not to
get stuck.

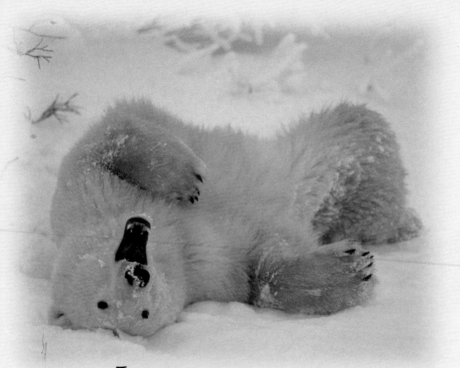

It helps if you have the ability
to laugh at yourself.

I f the world seems like too much on some days,
take time out to care for and protect yourself...

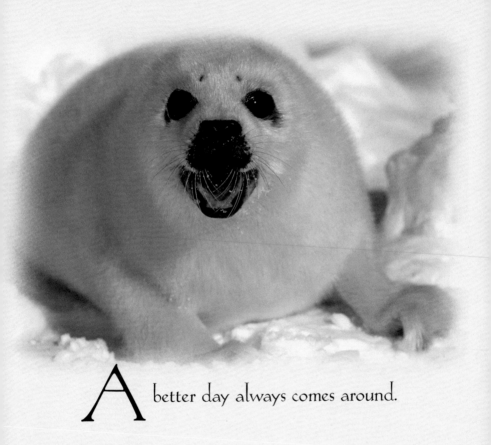

A better day always comes around.

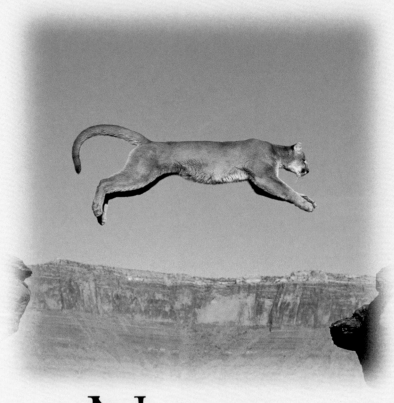

Never stop exploring.

Make the most of your potential...

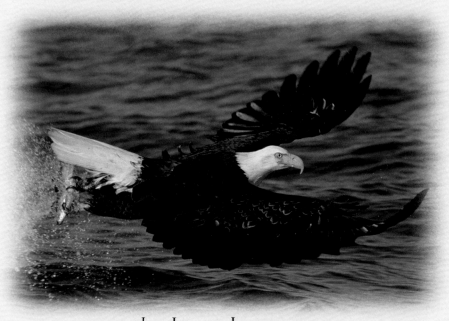

... and utilize to the utmost your
innate strengths and natural abilities.

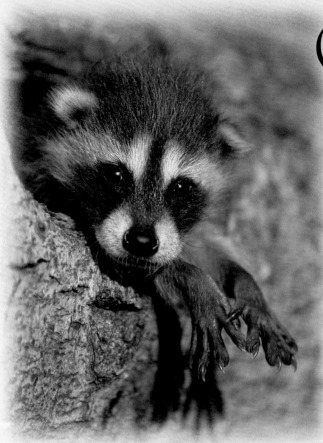

Give in
and ask for
help when
you're stuck.

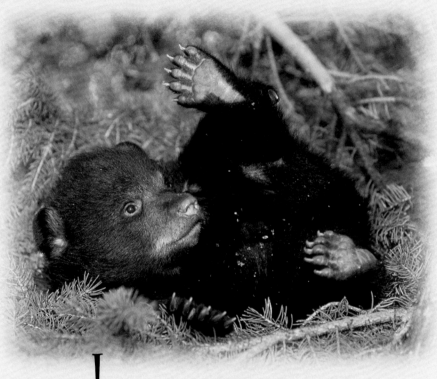

If you take a tumble, pick yourself up.

K eep a healthy sense of curiosity.

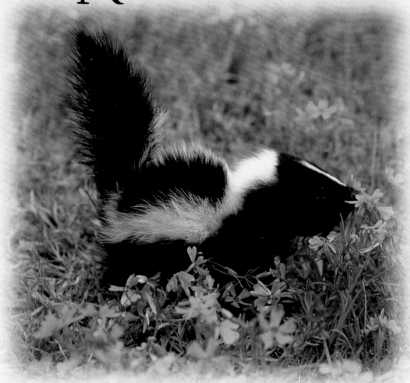

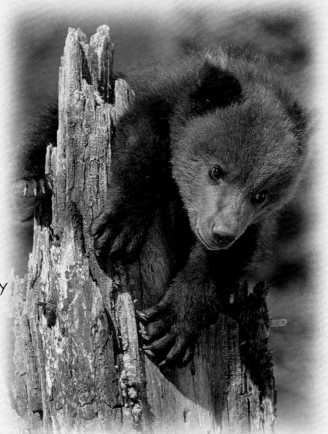

P ush
yourself to try
difficult and
challenging
things.

On
Day-to-Day
Living

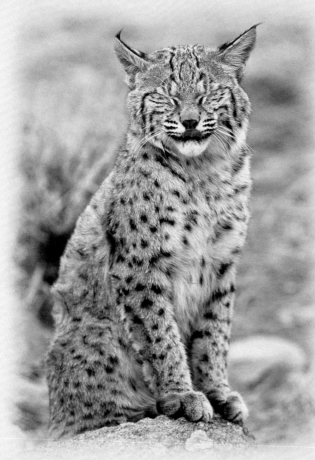

On some days, act your shoe size instead of your age.

Worry less...

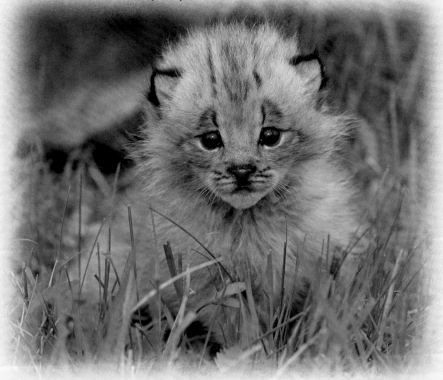

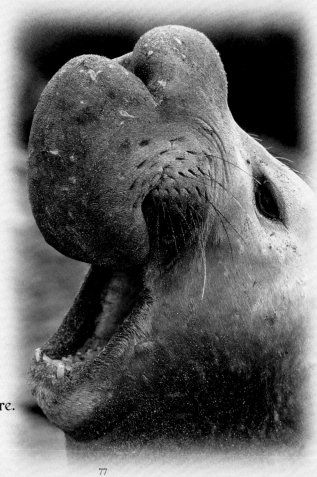

L augh more.

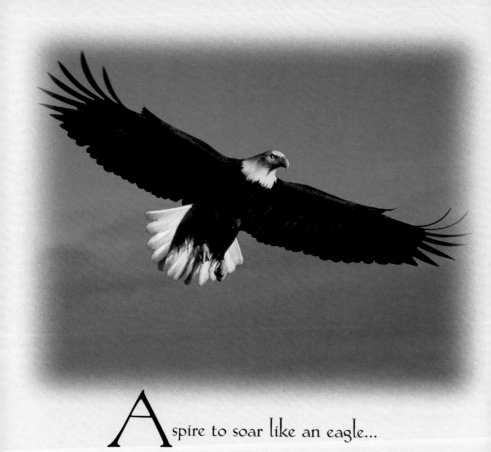

Aspire to soar like an eagle...

Even if you haven't yet learned how to fly.

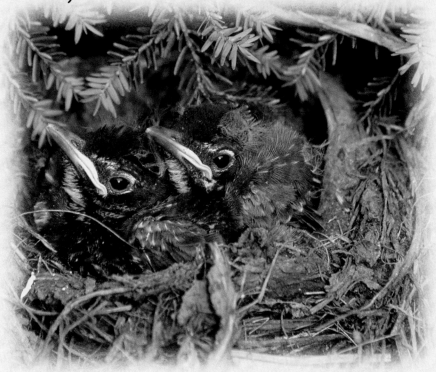

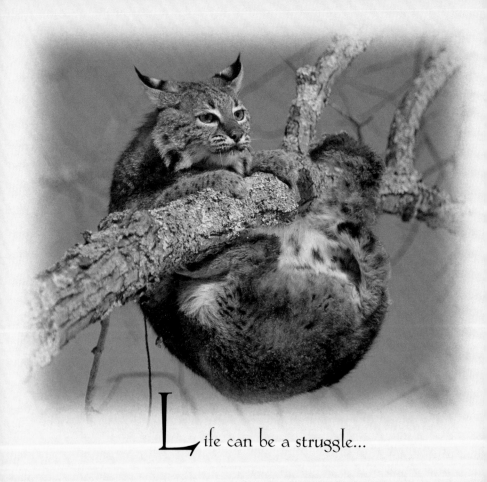

Life can be a struggle...

Full of ups and downs...

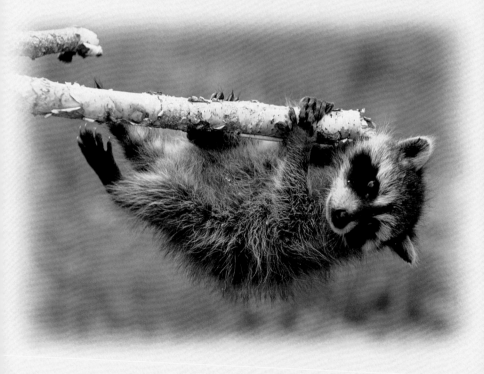

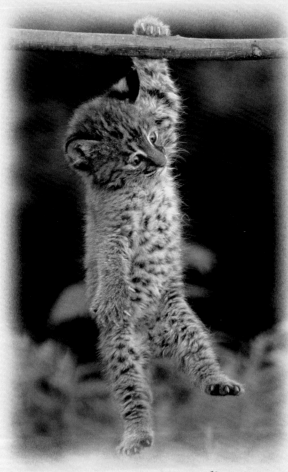

B ut you
just have to
hang on...

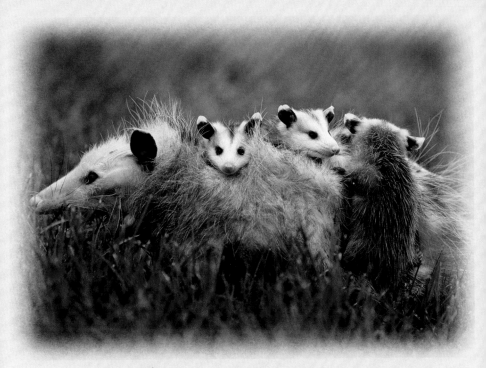

And if you do fall off,
climb back on!

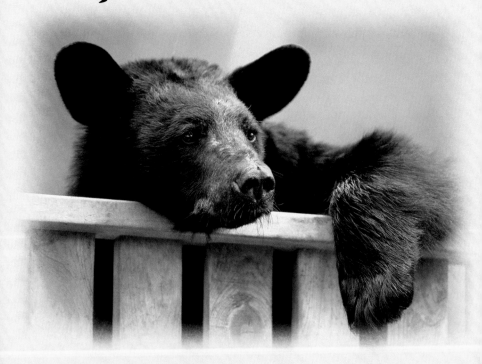

You won't find happiness on the
other side of the fence.

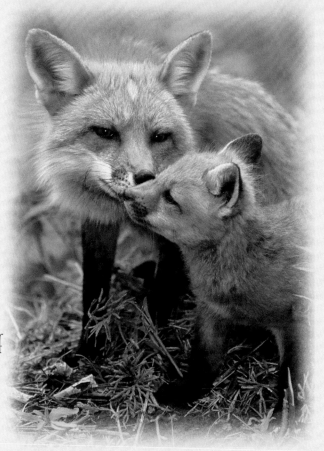

Listen to your parents — nine out of ten times, they're right.

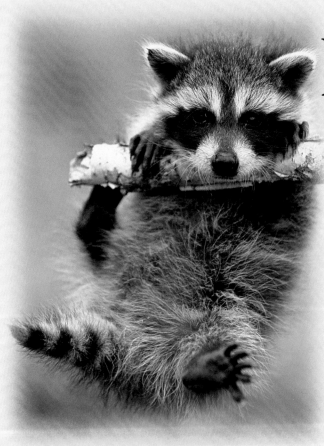

L earn to keep your cool in difficult situations.

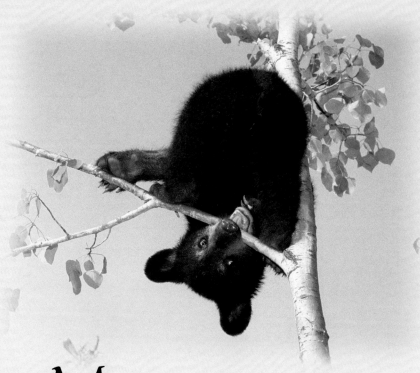

Most of our problems are self-created.

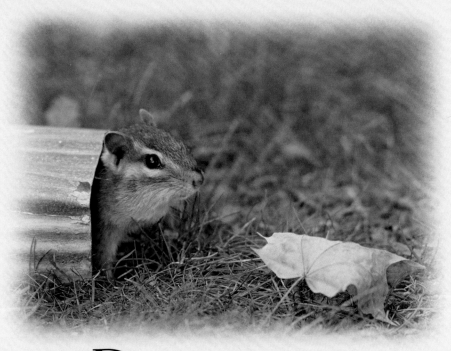

Don't be afraid of the world;
its not as big as it seems.

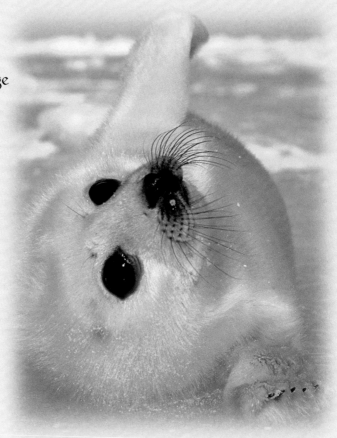

Change
is inevitable;
so learn to
roll with it.

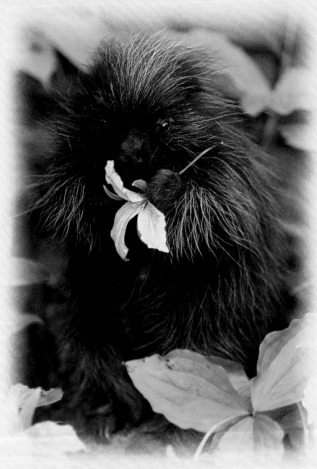

Be grateful
for the small
things in life.

E ven if
you sing
off-key,
sing loud!

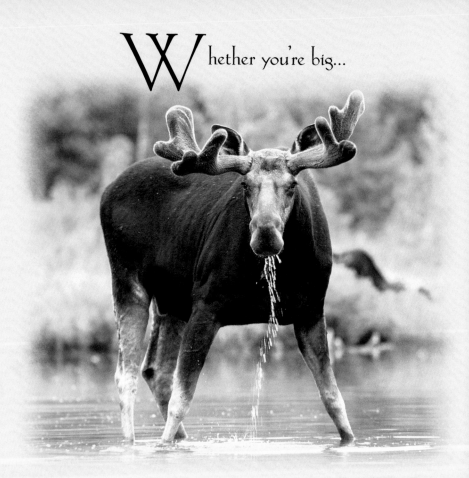

W hether you're big...

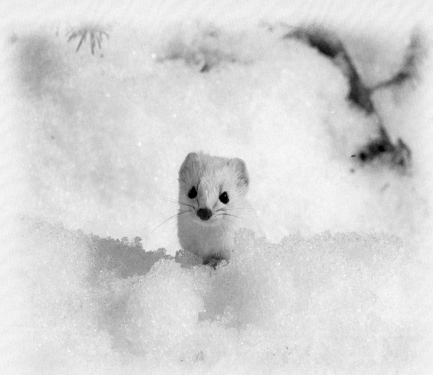

Or small, be prepared to defend your territory.

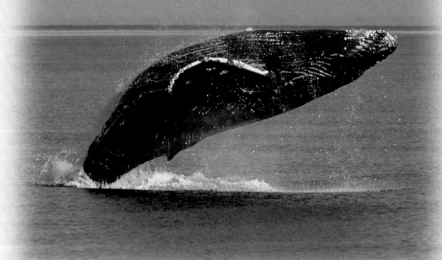

Leap for joy when you feel good.

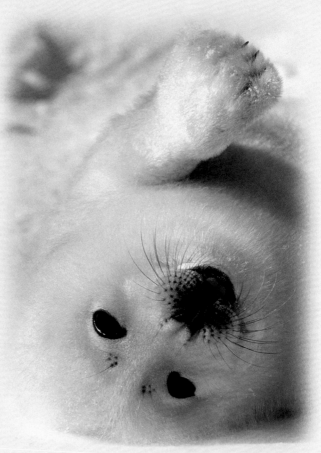

A smile cheers up everyone's day.

Always make time to appreciate
this beautiful world.

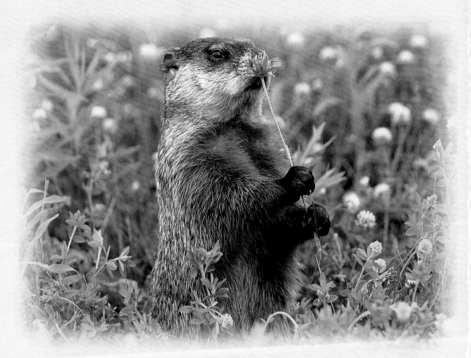